COVER & THIS PAGE Ed Pien | *Disembodied*, 2012 [detail] | photo by Roger Smith

TRACES

FANTASY WORLDS & TALES OF TRUTH

Daniel Barrow | Alison Norlen | Ed Pien

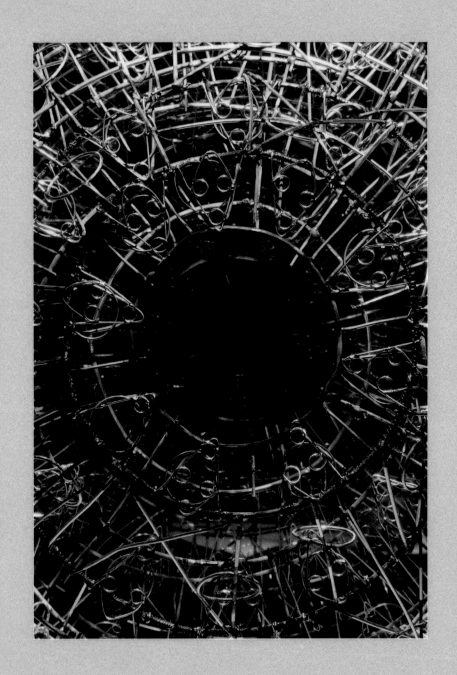

TABLE OF CONTENTS

TABLE OF

CONTENTS

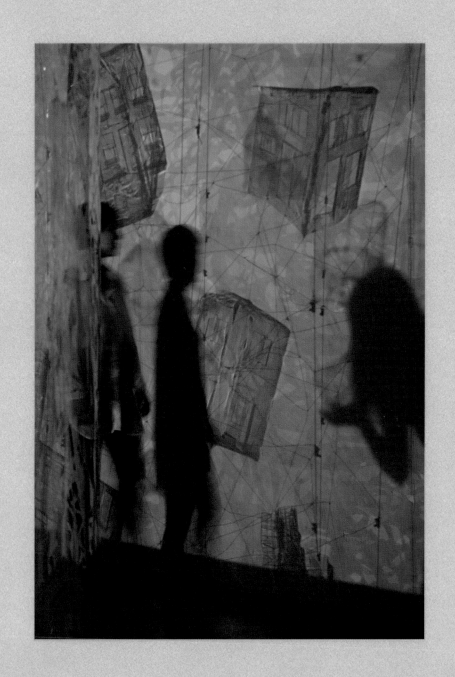

DIRECTOR'S FOREWORD

by

Jon Tupper

FACING PAGE **Ed Pien** | *Revel*, 2011 [detail] | photo by Roger Smith

DIRECTOR'S FOREWORD

by

JON TUPPER

D RAWING HAS TRADITIONALLY BEEN CONSIDERED A PRELIM-
inary medium, something that takes place before the actual artwork
is produced. For the past three centuries it has also been seen as one of the
most essential art forms.

The exhibition *TRACES: Fantasy Worlds and Tales of Truth* gives us a win-
dow into how the medium is being practised at this time. The three featured
artists, Daniel Barrow, Alison Norlen, and Ed Pien, make use of the medium
in fresh ways. Elements of memory, history, architecture, and narrative con-
nect their work at different levels. Curator Nicole Stanbridge has created a
thoughtful and enlightening investigation into contemporary drawing.

On behalf of the Art Gallery of Greater Victoria I would like to thank
the artists for their participation in the exhibition. I would also like to
acknowledge the financial support of the Capital Regional District, the BC
Arts Council, and the Canada Council for the Arts.

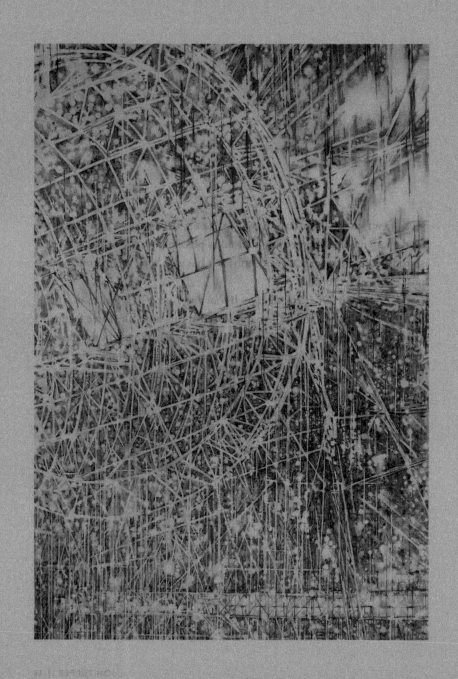

DRAWN FROM CURIOSITY

by

NICOLE STANBRIDGE

Drawing is an activity fundamental to human action.
It belongs with counting and speaking as being a primary
form of cognition. A people that did not draw would be
as unimaginable as one that did not count or speak, and,
if not too pedantic about how drawing is defined, we
may assert that the activity of making lines is a mode of
thought. A line, as it extends, takes in the world, and
because drawing may be both descriptive and prescriptive,
lines can model possible worlds. The form used to
represent the worlds (the objects) we seek to make is,
preeminently, drawing.

—David Brett, "Drawing and the Ideology of Industrialization"[1]

Drawing is an activity fundamental to human action. It belongs with counting and speaking as being a primary form of cognition. A people that did not draw would be as unimaginable as one that did not count or speak, and, if not too pedantic about how drawing is defined, we may assert that the activity of making lines is a mode of thought. A line, as it extends, takes in the world, and because drawing may be both descriptive and prescriptive, lines can model possible worlds. The form used to represent the worlds (the objects) we seek to make is, preeminently, drawing.

—David Brett, "Drawing and the Ideology of Industrialization"

DRAWING HAS BEEN A PRIMARY FORM OF COMMUNICATION throughout human history. It is fundamentally human. What distinguishes the work of Daniel Barrow, Alison Norlen, and Ed Pien is not just that they use drawing as their primary means of creation, but that they push the parameters and possibilities of what drawing can be. They take in the world through their own unique lens, filter it through their imagination and private thoughts, and send it back out into public space, having constructed for us a new world through drawing. This is a process, an exercise in finding new meanings and ways of perceiving the social, psychological, and physical realm we inhabit. The artists become storytellers, pillaging, collecting, and recording, then telling. We are lured in because we can sense a human presence in the work, whether physically there or not. These works are made by the artist's hand, not a mediated technology, and we sense the artist has experienced the material we are now witness to. This provides that coveted sense of authenticity that is somehow obscured by technology.

Within these bodies of work, the artists test the parameters of drawing through material, spatial, and thematic considerations. They tap into what is most appealing, or typically touted as valued, in art: "spontaneity, creative speculation, experimentation, directness, simplicity, immediacy, technical diversity, rawness, open-endedness, modesty of means."[2] Their work feeds into the ongoing exhaustive examination that has taken many directions over the last century, asking the question "What defines drawing?" Is it possibility, potential? These words can describe both the kind of vehicle drawing is as a form, and, likewise, how these artists exploit the medium of drawing. It is their curiosity about, and at times their critique of, human nature and social structures that is revealed through the fantastical realities and spaces they have constructed within the gallery.

Like the work of all good storytellers, the artists' imagined worlds captivate the viewer because they allude to and are informed by eerily familiar narratives. Through each artist's distinct vision of humanity, these illusory spaces—in some cases haunted by either memory or mythology—reflect back to us ugliness, despair, complexity, beauty, opulence, and frivolity. Our role

as the viewer is to read these works with the same curious impulse as the maker. We are asked to seek out and participate in the narratives as active agents, investigating the traces left and lines made.

What does it mean to say something is a drawing—as opposed to a fundamentally different form, such as a photograph? First of all, arriving at the image is a process, not a frozen instant. Drawing for me is about fluidity. There may be a vague sense of what you're going to draw but things occur during the process that may modify, consolidate, or shed doubts on what you know. So drawing is a testing of ideas; a slow motion version of thought. It does not arrive instantly like a photograph. The uncertain and imprecise way of constructing a drawing is sometimes a model of how to construct meaning. What ends in clarity does not begin that way.
—William Kentridge, *William Kentridge*[3]

D rawing, the act of making, leaving, and finding traces, creates a record; it is evidence about who, what, and where we are. As Kentridge states in the quotation above, "it is a slow motion version of thought"—thought and meaning made visible, communicating the presence and process of the mark maker. In Karen Kurczynski's essay "Drawing Is the New Painting,"[4] the first two paragraphs are a compilation of statements—or, as Kurczynski calls them, "truisms"—about what drawing is. One of these truisms states that "drawing is private," but as we will see in the work of Barrow, Norlen, and Pien, it can also comfortably and confidently inhabit public space. Kurczynski also writes that "it is a fragment of a new world, or it is a partial memory of the past." But as we see in Norlen's homage to sites of cultural history, it can in fact be both. Drawing can also be "the trace of a unique human subjectivity," as is evident in the fantasy worlds conjured into reality by these three artists. Kurczynski goes on to say that "drawing is impossible to define."

Perhaps a concrete, definitive classification of drawing is unattainable. Nevertheless, exploring its potential, what it can be, is an exciting and worthwhile endeavour. The belief that drawing can be much more than a line on paper, confined to a select range of media, has been tested for some

time now, and by building on ideas that attempt to define contemporary drawing, we are able to capture the essence of what appeals to us about this form of expression. We can also see how those intrinsic characteristics translate beyond the intimate private space of the artist's sketchbook into an epic use of scale and articulation of three-dimensional space.

While drawing may begin as private, in order to be recognized it must become public. It can easily be re-monumentalized, in two ways: as installation, where drawing manifests its inherent hybridity, or as overly finished, finely crafted product, for example in the work of prominent artists like Julie Mehretu and Matthew Ritchie.

—Karen Kurczynski, "Drawing Is the New Painting"[5]

These two propositions, that drawing can be done in any medium and that it can be "re-monumentalized," are key points that unify the diverse practices of these three artists. As we see throughout the work in this exhibition, drawing can be done in wire, rope, or mylar. These materials can be cut, tied, soldered, and projected onto the wall, and the result can be highly finished or open-ended. In every instance, the artist pushes the potential of materials, investigating, experimenting with the way each of those materials is loaded with its own range of expectations that are being challenged. For example, playing with scale and material, Alison Norlen constructs soldered wire "drawings," such as *Glimmer* (*Zeppelin*) and *Roundabout*, which function as studies in three-dimensional space for her larger two-dimensional works on paper. What becomes apparent is that these artists delight in material explorations, trying to figure out how big or how far drawing can go. They share an enthusiasm expressed so effusively by Samuel Palmer, a nineteenth-century British landscape painter heavily influenced by William Blake: "There are many mediums in the means…one must not begin with medium, but think always on excess, and only use medium to make excess more abundantly excessive."[6]

It is the experimentation and investigation of material that leads to an articulation of how the medium chosen can be manipulated to embody the

line, gesture, and sense of space the maker requires of it. Starting with what may be considered, at first view, a relatively traditional mode of drawing, Ed Pien's expansive work on paper, *Grand Thieves*, done with ink and Flashe paint, is a vibrant and frenetic mass of forms reminiscent of a figure study, but here the dismembered, distorted beings appear to have escaped from a nightmare or mythological tale. They overlap and clamber on top of each other, several managing to break free into white space. It is a fascinating window into Pien's imagination, and a privileged view. It is as though we are witnessing a purge of data, imagery that has accumulated in his mind from the stories, myths, and personal narratives he has built to reflect and understand the world we inhabit. Unfinished, immediate, and spontaneous – these traits are key to Pien's practice and relate back to those recognized attributes of art that we connect to so fundamentally. For Pien, they allow his work to be living entities: as works of art they are never complete. There is not a fastidious need to produce a completely resolved and finished product; he could return to these works and rework them, elaborate on them. For instance, with his installation *Revel*, he has collaborated with Jenny Pham and Phil Baljeu to create a new layer to the work: sound. Here is yet another material possibility introduced to the presentation of this form called drawing. For Pien, the process subsides when the work is brought out into the public realm, but the potential for it to evolve and transform remains in the imagination and at the hand/whim of the artist.

The sense of immediacy and spontaneity that manifests in form is also readily present in the work of artists like Nancy Spero or Kara Walker, whom Pien notes as two of his influences. In subject matter, Spero and Walker similarly use mythology and socio-political histories to inform their narratives. There are parallels in the way they are able to use the human form as a tool, a medium by which an intangible emotion is made visible through powerful and fierce imagery. There is a complexity to the constructed bodies that confront us in their work. They are seductive and exquisite but also, at times, altogether grotesque and violent.

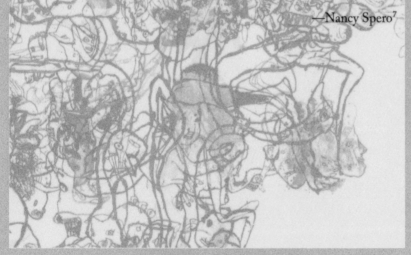

The time is drawing near, drawing closer to the apocalypse and we are drawing away from reality, drawing toward extinction. We must not be drawn in or aside, drawing blinds across our eyes, but be drawn out of ourselves, all drawing together, drawing strength in unity of purpose. Let's not draw a dirty picture, let's draw a pretty one!

—Nancy Spero[7]

Ed Pien | *Grand Thieves, 1999–2010 [detail]* | photo by Toni Hafkenscheid

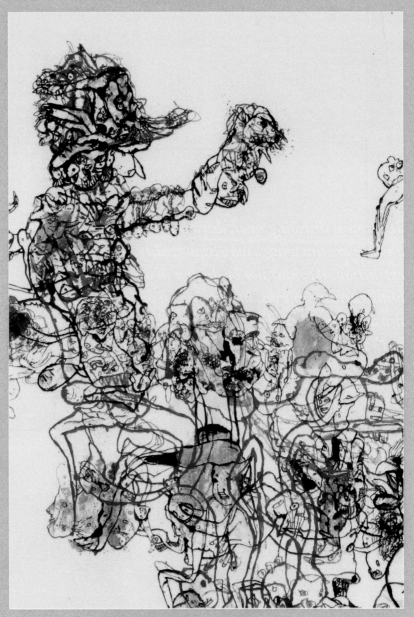

Ed Pien | *Grand Thieves*, 1999–2010 [detail] | photo by Toni Hafkenscheid

Three new works from Pien's *Spectral Drawing* series—*Disembodied, Professional Mourner, Out-of-Body*—function in a similar way to *Grand Thieves* in that they evoke a stream of consciousness drawn into existence, immediate and visceral. As the title of the series suggests, they generate an ethereal haunting presence, executed in white ink on black paper. Like Norlen's drawings *Glimmer (Parachute Drop)* and *Glimmer (Zeppelin)*, these works appear as ghostly visions. Pien's are suspended in space, forming a geographical map of some impossible world that exists as uncharted imagination, while Norlen's are suspended in time, architectural bodies hovering as an imposing edifice with their skeletal framework exposed.

Using a range of chalk, charcoal, and spray paint, Alison Norlen, like Pien, constructs her illusory worlds on a large scale. The subjects of her drawings—the zeppelin or the Parachute Drop carnival ride—exist as ephemeral, open-framed structures that appear almost as visions. Fragile but imposing, the scale is "proportionate to human size, which elicit[s] a slightly uncanny association in the viewer, one body to another. There are other cues to our physical identification with the corporeal nature of these forms also: their skeletal organization, their organic curves, their porosity."[8]

This encounter of human scale, "one body to another," continues throughout the exhibition. On approaching Pien's installation *Revel* and Barrow's *The Thief of Mirrors*, for example, a stage is set for interaction and performance to take place. Using modest materials, the artists have created fantastical environments, whose elaborate presence and scale suggest theatricality. In both instances, we, as viewers, are lured into and implicated in the work through our participation. In Pien's *Revel*, our intrinsically curious nature invites us to investigate this seemingly fragile three-dimensional mylar structure with a complex web of imagery carved out of the mutable material that shifts with the light, projection, and human presence. Here we are met, literally, by another body in the work. The reflective sheen, shadow, and architecture of the mylar is illuminated and becomes a wash of texture on the wall. The projection of a woman's shadow cuts through the structure to investigate the intricate formation on the wall. The viewer's

shadow, now sharing the same space as the drawing and the apparition of the woman's figure, further involves us in the function of the work through our presence.

Indeed drawing is part of our interrelation to our physical environment, recording in and on it the presence of the human. It is the means by which we can understand and map, decipher, and come to terms with our surroundings as we leave marks, tracks, or shadows to mark our passing.

—Emma Dexter, *Vitamin D: New Perspectives in Drawing*[9]

Caricature, as a rebellious niche in the history of drawing, is a means through which we can come to terms with and critique the social climate of the day. Daniel Barrow's work seems to locate itself within that niche of caricature in a very curious and contemporary way. Considered for some time a marginal style of drawing, caricature is now, as Deanna Petherbridge argues in *The Primacy of Drawing*, "the ultimate postmodern medium … central to contemporary drawing practice." Its relevance is that it comes from everyday life as "popular commentary and critique." [10] It is expressive, exaggerated, often grotesque, and comical. We can go back through history to see established artists, like George Grosz or Honoré Daumier, use this so-called marginal style of drawing to critique the power structures and social ills at play in their respective eras. For British cartoonist Ralph Steadman, best known for his work with Hunter S. Thompson, the caricatures of George Grosz offered up a wealth of potential and a potent example of what drawing could be:

It was my first encounter with the works of the German artist George Grosz, when I was in my twenties, which showed me that drawing need not just be a space-filler in a newspaper: in the hands of an honest man, drawing could be a weapon against evil … Look at [his drawings] and you know the world is sick. You may say that he was sick too–but it is a common mistake to believe that sick drawings indicate a sick mind, rather than a reflective indictment of society. His drawings scream indelibly of human depravity; they are an eloquently barbaric response to life and death, right through the First World War and into the wild, helpless excesses of 1920s Berlin, which rotted away the lives of all those caught up in its suicidal glee.

—Ralph Steadman, "Broader Picture: Ralph's Grosz Misdemeanours"[11]

Daniel Barrow | *Devil*, 2012 [detail] | photo by Blaine Brodi, WAG

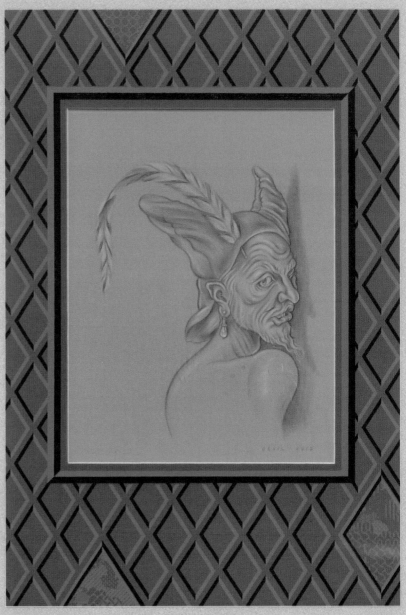

Daniel Barrow | *Devil*, 2012 [detail] | photo by Elaine Stocki, WAG

Much like Grosz's critique of 1920s Berlin, Barrow's *The Thief of Mirrors* is a contemporary response to the excesses of the elite. The installation, which takes the form of what Barrow describes as an "experimental moving picture experience," is meant to create and then elaborate upon an emotionally complicated portrait of wealth and privilege. The follies of the elite, with their insatiable greed and voracious overindulgence, is a timeless theme for artists. Travelling even further back, to nineteenth-century France, we find a lithograph by printmaker, caricaturist, painter, and sculptor Honoré Daumier that targeted the corrupt French king Louis-Phillipe. His drawing *Gargantua* (1831) depicts an obese king with a potbelly and pear-shaped head, gorging on bags of gold fed to him by his members of parliament. Daumier's caricature alludes to the giant Gargantua from François Rabelais's controversial series of stories. These tales of Gargantua were parables that allowed Rabelais to convey questions he had about his own ideals of humanism,[12] much like the tales spun by Barrow in *Thief of Mirrors*. In his image of contemporary society, what kind of world is Barrow reflecting back to us? Writing about the 2006 exhibition *For the Record: Drawing Contemporary Life*, Daina Augaitis concludes her essay with a similar question: "So what kind of world is recorded? In our contrary (mis) understandings of it, it seems a place that is uneasy, jolly and dangerous, yet full of promise."[13]

"A place that is uneasy, jolly and dangerous, yet full of promise." This aptly describes the world that Daniel Barrow constructs for us in his portraits. He tackles the dangers of excess greed, wealth, and privilege head on, in all their ugliness, depicting them in ways that charm and stun us, yet are equally tragic and horrifying. Influenced by popular culture and the obsolete technology of magic lantern shows from the seventeenth century, Barrow, as narrator and animator, recounts these fantastic tales to us through his performance. His storytelling has evolved from sophisticated notebook doodles to complex moving pictures, uncomfortable truths projected in all their perverse glory. Like Rabelais's tales of Gargantua, Barrow's stories function as parables, as a means to perhaps awaken our humanity and see

through the illusions of opulence and excess. Like Pien, he engages us by involving us in the action of his narrative, but does not necessarily prescribe for us a remedy to the situation. His mirror reflects a particular view of reality back to us and asks us to awaken from our complacency and question what our ideals of humanism might be, imagine for ourselves the creation of another possible world. We are implicated in the work by our presence and our actions. The theatrical scale of the projection creates a life-size stage that we are invited to animate by moving the mylar sheets on the overhead projectors. There is no "man behind the curtain": the apparatus that creates the illusion is not hidden but on display with the work to be seen, and the tools and construct of the illusion are exposed for us to encounter and engage. The piece can be viewed as both a performance by the artist, who narrates and animates the story, and as an interactive installation set in motion by the viewer. It is this creation of architectural spaces with drawing, whether tangible or illusory, that brings us into the work in a way that pushes the potential of drawing.

As viewers we are offered a privileged view, a look behind the curtain that exposes the tools that form the illusion. This disruption of the illusion and unveiling of the apparatus of deception is also evident in aspects of Norlen's work. Her simulated virtual worlds are not tangible, like the "thing" or place they portray once was in its time. In order to understand the structures, she brings them from the past into a contemporary context and constructs a new version of them, as we see with her soldered wire drawing, which is scaled down to a proportion she can encounter in real space. This process allows her to know her subject in a tangible way; it enables her to not only illustrate it, but also understand its structure, not as a memory or document, but as a lived experience. In the catalogue for Norlen's 2011 exhibition *Glimmer*, contributing writer Shauna McCabe describes Norlen's work as "architecture as art as archive," and goes on to say that "the potency of her images lies in their resulting ambiguity, establishing a cascading relay that is never quite reconciled, between the space of imagination, space of memory, and space of things."[14]

The source materials that inform Norlen's work are not stand-ins for the things themselves but evidence of them. Archival images, writing, and stories of places or things past build an image but are only illusions, articulated, immortalized, and constructed from memory. These narratives are collected, like material, and then observed and recorded as evidence in the work of Norlen, Barrow, and Pien. It is in this way that artists "have been and continue to be hunters and gatherers and plunderers and scavengers."[15]

Memory is a crucial part of Norlen's narratives, as those familiar spaces implicate and capture the viewer's imagination. Even though memory is elusive and very subjective, it is also the key that locates us within our collective histories and culture.

We remember experiences and events which are not happening now, so memory differs from perception. We remember events which really happened, so memory is unlike pure imagination … Some memories are shaped by language, others by imagery. Much of our moral and social life depends on the peculiar ways in which we are embedded in time.

—"Memory," *The Stanford Encyclopedia of Philosophy*[16]

The sites Norlen chooses to reproduce are already loaded with histories and purpose, and are attributed to another creator/designer/architect; those are their traces. Her part in creating new versions of them is not simply to illustrate the original but to create a new space of interaction informed by a new perspective. Filtered through imagination, a new memory is created, a new trace is made. We relate to these structures because they speak of human presence without the figure ever being articulated in their space. There is history, nostalgia, and a collective memory of them that allows us to fill in the blanks. We understand them as sites of human activity even when they are depicted as vacant sites.

What is consistent in the work of Daniel Barrow, Alison Norlen, and Ed Pien is the evidence of the artist's hand. It is what we connect to. However big or small the work, we can imagine that sense of intimacy, the artist's presence in constructing and manipulating the material to its

ultimate end. This is how they leave traces, hints, signs, indications, evidence that can be discovered and found, that locates, can be followed, and alludes to the mark maker. It is a means of mapping out, marking out. Tracing is an act, a record of a trace made. A trace is the result of an action that records, a gesture – like a drawing. It is something left as a mark, like a path or footprint, functioning as evidence of someone or something, existing as a remnant, a vestige of something past.

I believe that in the indeterminacy of drawing, the contingent way that images arrive in the work, lies some kind of model of how we live our lives. The activity of drawing is a way of trying to understand who we are or how we operate in the world. It is in the strangeness of the activity itself that can be detected judgment, ethics and morality.

—William Kentridge[17]

[1] David Brett, "Drawing and the Ideology of Industrialization," in *Design History: An Anthology*, ed. Dennis P. Doordan (Cambridge, MA: MIT Press, 1996), p. 3.

[2] Michael Craig-Martin, quoted in *The Drawing Book. A Survey of Drawing: The Primary Means of Expression*, ed. Tania Kovats (London: Black Dog Publishing, 2005), p. 15.

[3] William Kentridge, *William Kentridge* (London: Phaidon Press, 2003), p. 8.

[4] Karen Kurczynski, "Drawing Is the New Painting," *Art Journal* 70, no1 (Spring 2011): 92–110.

[5] Ibid.

[6] Quoted in Deanna Petherbridge, *The Primacy of Drawing* (New Haven, CT: Yale University Press, 2010), p. 120.

[7] Nancy Spero, quoted in ibid., p. 432.

[8] Joanne Marion, "The Power of Imaginative Projection: Alison Norlen's *Glimmer*," in *Alison Norlen: Glimmer* (Saskatoon, SK: Kenderdine Art Gallery, 2010), p. 20.

[9] Emma Dexter, *Vitamin D: New Perspectives in Drawing* (London: Phaidon Press, 2005), p. 6.

[10] Petherbridge, *The Primacy of Drawing*, p. 377.

[11] Ralph Steadman, "Broader Picture: Ralph's Grosz Misdemeanours," *The Independent* (London UK), March 16, 1997, http://www.independent.co.uk/arts-entertainment/broader-picture-ralphs-grosz-misdemeanours-1273306.html.

[12] Yvonne Merritt, "The Unquenchable Thirst to Understand: Francois Rabelais' Satire of Medieval and Renaissance Learning In *Gargantua and Pantagruel*," *Ampersand* 2, no 2 (Spring 1999), http://itech.fgcu.edu/&/issues/vol2/issue2/rabelais.htm.

[13] Daina Augaitis, *For the Record: Drawing Contemporary Life* (Vancouver: Vancouver Art Gallery, 2003), p. 21.

[14] Shauna McCabe, "Architecture as Art as Archive: The Analogous Spaces of Alison Norlen," in *Alison Norlen: Glimmer* (Saskatoon, SK: Kenderdine Art Gallery, 2010), p. 9.

[15] Petherbridge, *The Primacy of Drawing*, p. 180.

[16] John Sutton, "Memory," in *The Stanford Encyclopedia of Philosophy* (Stanford University, 2010), substantive revision February 3, 2010, http://plato.stanford.edu/archives/sum2010/entries/memory/.

[17] William Kentridge, quoted in *The Drawing Book. A Survey of Drawing: The Primary Means of Expression*, ed. Tania Kovats (London: Black Dog Publishing, 2005), p. 35.

UNHOMELY
SPACES

by

Sally Frater

Daniel Barrow, The Face of Winter, 2012, detail

UNHOMELY
SPACES

by

Sally Frater

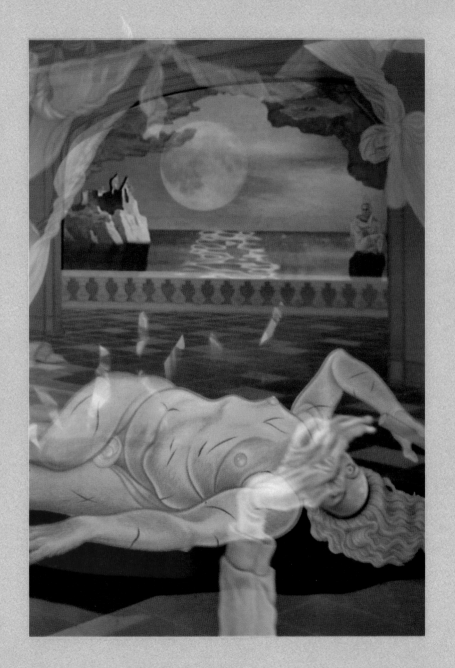

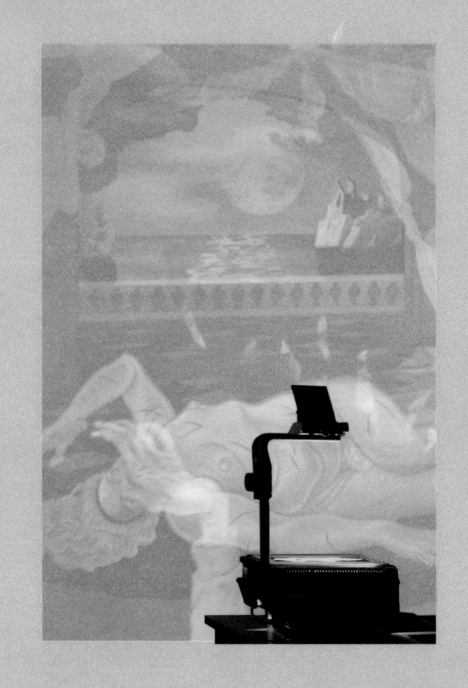

IN ANNELEEN MASSCHELEIN'S BOOK *THE UNCONCEPT*, WHICH is essentially a genealogy of Freud's concept of the uncanny,[1] the author cites Lloyd Smith's work *Uncanny American Fiction*, which proposes that the act of writing is an uncanny act, as the very gesture of recall that it brings forth is itself a manifestation of the uncanny.[2] This is because the act of remembering that writing elicits is predicated on the fact that the reader will have some knowledge of, or familiarity with, that to which the author refers, yet it is utterly impossible that the author will be able to present his or her subject in a manner that mirrors its original context. The same observation can be made of art making, for in producing work, artists often employ a coterie of signs and signifiers that, having been introduced to viewers in contexts outside the framework of the artists' specific artwork, transform into the uncanny once they are deployed within a work of art.

In Freudian terms, what designates an object or condition as uncanny is the element of terror or haunting, which is connected to something once known and familiar. This element can be found throughout the oeuvres of artists Daniel Barrow, Ed Pien, and Alison Norlen, all of whom depict environments that disturb our sense of the familiar while invoking the uncanny via their various gestures of replication by means of artistic representation. Through the materiality of their drawing-based practices, the artists rupture known terrains of nostalgia, revealing frameworks of despair, trauma, and alienation.

Daniel Barrow's *The Thief of Mirrors* (2012) is an interactive multimedia drawing installation, containing elements of performance and audience participation. A large portion of the work consists of drawn overhead projections that depict the interior of a manor, which overlooks an idyllic scene on a lake. The installation features a layering of fluttering imagery that produces an ethereal effect, achieved by the inclusion of fans and by the fact that the images are projected through water. The colourful palette of the illustrated scenes that appear on the overhead projections is redolent of a fairytale, yet the nature of what is shown departs significantly from the content of fairytales retold by Disney. Before a shattered mirror, shards of

glass fall toward a nude figure that lies on the ground in a state of repose, delicately grasping a hammer.

While the work implies a strong sense of narrative, it is unclear what exactly has transpired in the depicted scenes. We can safely assume that there has been a struggle, but whether it was with another or was an internal fight remains uncertain (although the broken mirror supports an interpretation of self-rejection). The inclusion of a disembodied white hand that passes along the bottom of the work adds to our confusion and to our suspicion that something foul is afoot. The sense of fragmentation inherent in the work is reinforced by the fact that Barrow has produced a number of overhead "plates" that viewers are invited to interchange at random, allowing them to determine the order in which the work's narrative will unfold. This ensures that no resolution is reached within the work, keeping both the viewer and the piece in a perpetual liminal space. The violence implied by the work unsettles the notion of the home as a safe harbour, and renders the site of the house "unhomely."[3]

Another interactive projection piece that incorporates performance, Ed Pien's *Revel* (2011) operates in an entirely different fashion than Barrow's *The Thief of Mirrors*, though it also explores the notion of the "unhomely" in a literal and figurative sense. The installation features a video of a young woman in silhouette, projected through a sheet of mylar that is hung in a vertical spiral. Viewers can enter into this space, and when they do, their silhouettes become a part of the projection, implicating them in the narrative. Hung around the spiral are sculptures of houses that are constructed in a manner resembling either a child's drawing of a home or the type of illustration of a house that would appear in a children's book. In the video, the young woman is seen holding structures similar to the sculptures within the installation. She interacts with the sculptures, at times holding them in seeming contemplation while at other points dropping them altogether. On one level, the work easily lends itself to readings regarding the confinement of domesticity and gender; yet on another level the work can be interpreted as undermining the notion of the home as a safe haven. The translucent nature of the mylar

gives the work a ghostly, ephemeral air while bringing forth the binary of public and private in a highly visible manner.

Alison Norlen's images are ghostly, but in a manner that differs from the works of both Barrow and Pien. The large-scale drawings from the artist's *Glimmer* series loom large before viewers, their presence foreboding. Under highly worked-up surfaces of cool whites, blues, and purples, faint outlines of structures emerge: the tracks of a roller coaster, a zeppelin, and a bridge can be detected beneath a heavy impasto of white pastel. Devoid of the presence of human figures or activity, Norlen's renderings emanate an eerie quality. We are unsure whether her drawings are documenting spaces that have been abandoned due to a catastrophic event – the structures within the works appear fragile and seem to be caught in a moment of disintegration or dissipation, a sense that is underscored by the overlay of white pastel, which makes the works appear to be documents capturing the aftermath of an ice storm.

Norlen's works are all documents of things that exist in reality, yet when they appear in her art we are not quite sure how to receive them, for they exist in what are essentially non-places. Removed from their original contexts, they disrupt our sense of the familiar regarding the scenes with which we are confronted. *Parachute Drop* (2009) is a rendering of an amusement park ride that at one time figured prominently in the landscape of Coney Island. For those familiar with any type of amusement park, there exists a particular configuration of sights, smells, and sounds that accompany the recall of such a setting, yet Norlen's depiction is essentially bloodless. Instead of the bright palettes and dynamism typical of amusement parks, we are presented with a stillness that threatens to overwhelm us, particularly when paired with the scale and vertical format of the work.

Norlen's works on paper make it difficult to derive a sense of narrative because they give the sense of functioning as snapshots of moments frozen in time. Due to both the perspective offered in each drawing as well as the fact that each piece on paper is mounted directly to the wall, it is as though we are prevented from entering into them.

During encounters with that which is familiar, there is the expectation that we will engage with something that is comforting. The work of Barrow, Pien, and Norlen present us with familiar tropes and depictions, which at first glance provide the impression that they will operate in this manner. However, they turn out to be something else altogether. We approach the scenes and scenarios with recognition, yet our encounters are alienating and we are left with a feeling that can best be described as anxiety—not only because we are disturbed by what we are looking at in their particular works, but also by the suggestion that perhaps our past encounters with what we held to be familiar always contained elements that would disturb our sense of propriety... had we recognized them as such.

[1] Mike Kelley describes the uncanny as "the class of the terrifying which leads us back to something long known and once very familiar, yet now concealed and kept out of sight." This is a useful definition for the works in this exhibition, as it describes what they do. As well, they move beyond this and reveal that which is normally hidden. (Mike Kelley, "Playing with Dead Things," in *The Uncanny*. Arnhern: Genmeentemuseum Arnhern, 1993), p. 25.

[2] Anneleen Masschelein, *The Unconcept* (New York: SUNY Press, 2011), p. 129. Masschelein states that "the text is not itself a faithful representation or memesis of reality, it is the representation of a fundamental absence or repression," while Smith's actual text states, "Writing itself is uncanny: the generation of the uncanny in fiction is often at the point when writing bends back upon itself."

[3] Massechelein, *The Unconcept*, pp. 142–43. The term "unhomely," which is a translation of the German word *unheimlich*, is often used interchangeably with "uncanny." Here it is used to denote a literal disturbance of the site of habitation.

WORKS OF ART

by

Daniel Barrow | Alison Norlen | Ed Pien

WORKS OF ART

&

Daniel Barrow | Allyson Mitchell | Ed Pien

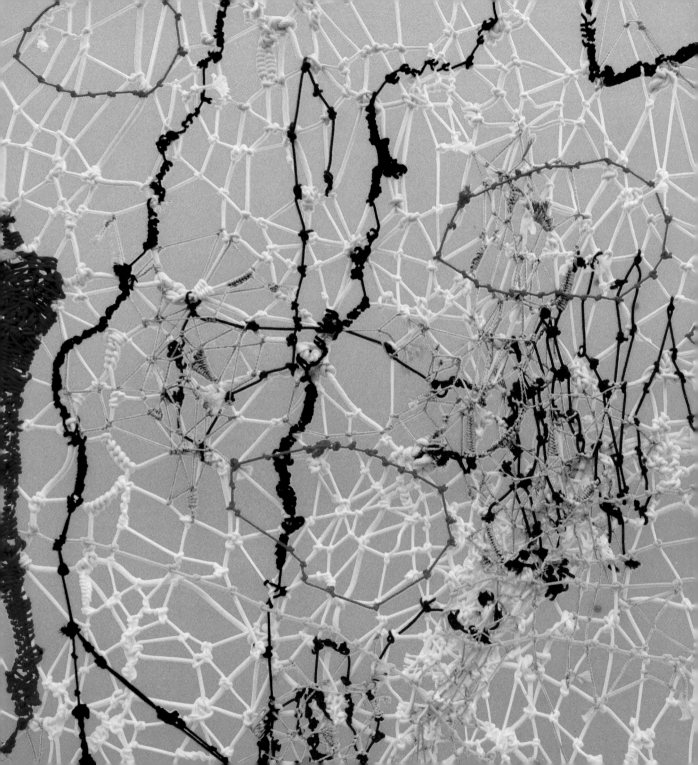

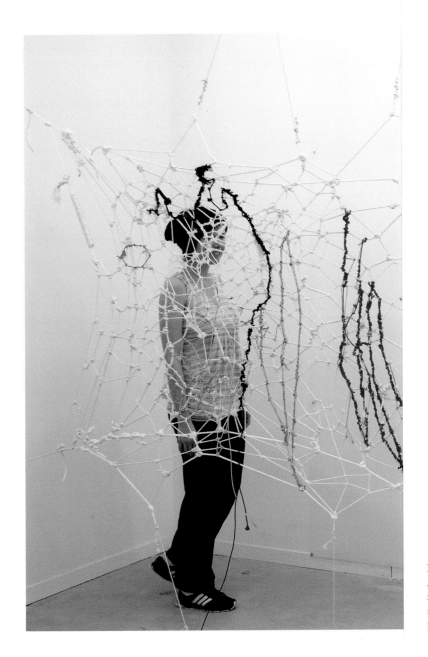

Ed Pien
Play Rope drawing, 2012
rope
2.7 x 3m
photo courtesy of the artist

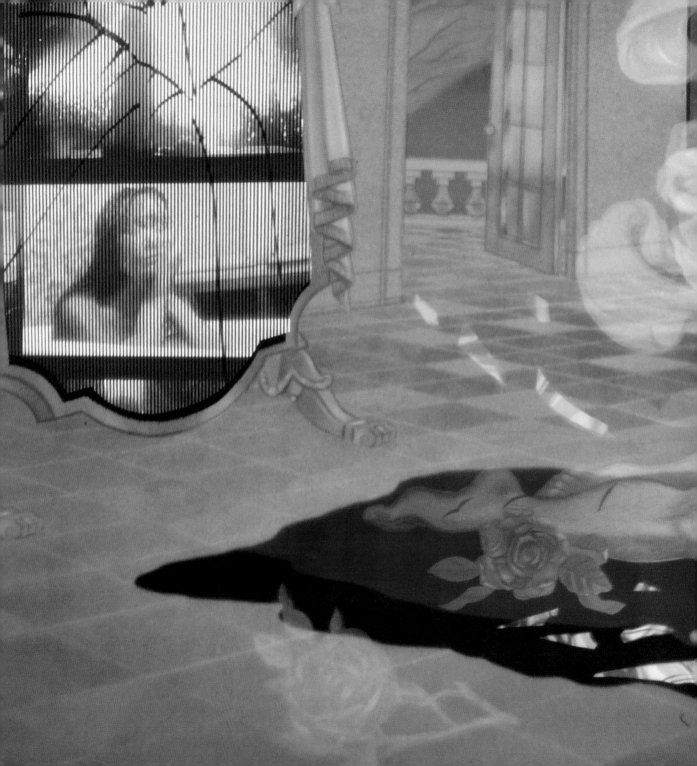

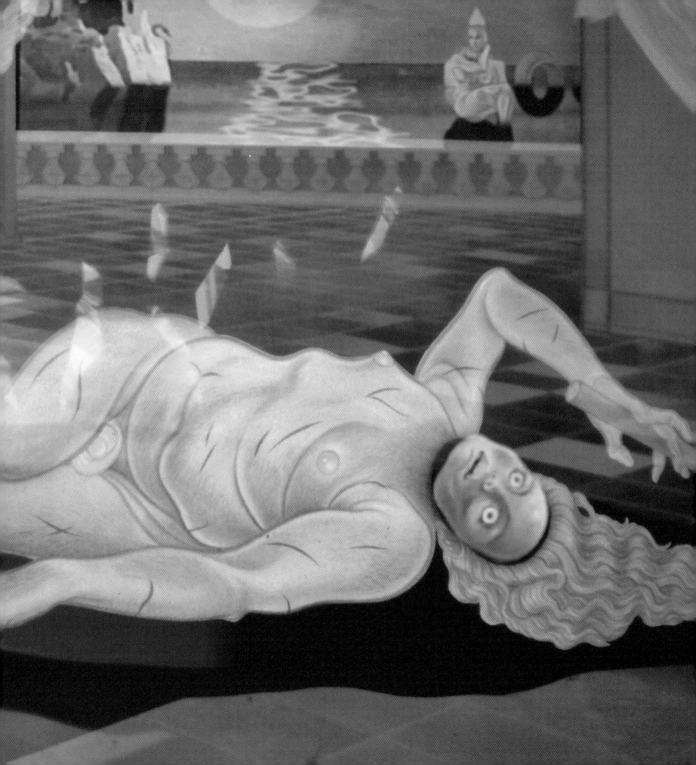

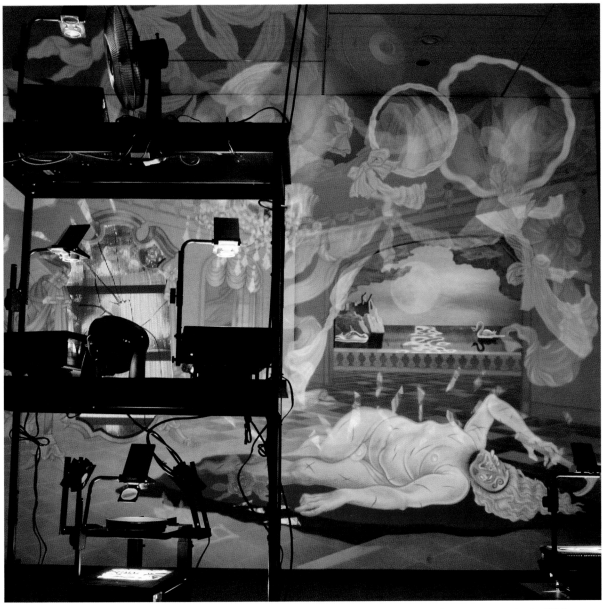

Daniel Barrow | *The Thief of Mirrors*, 2012 [detail] | mylar, overhead projectors, fans | dimensions variable | photo by Elaine Stocki, WAG

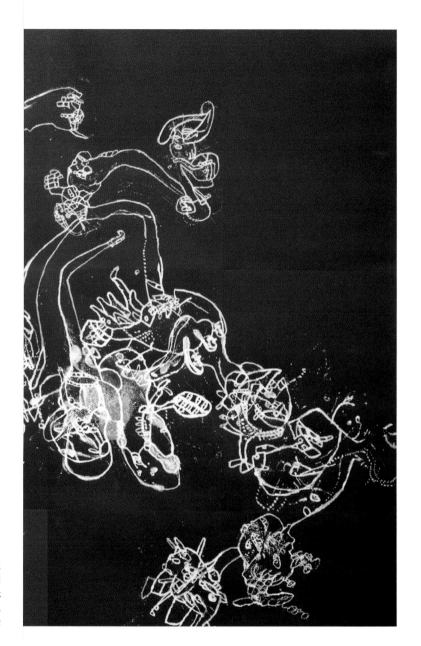

Ed Pien
Out-of-Body, 2012
paper and ink
116.8 x 81 cm
photo courtesy of the artist

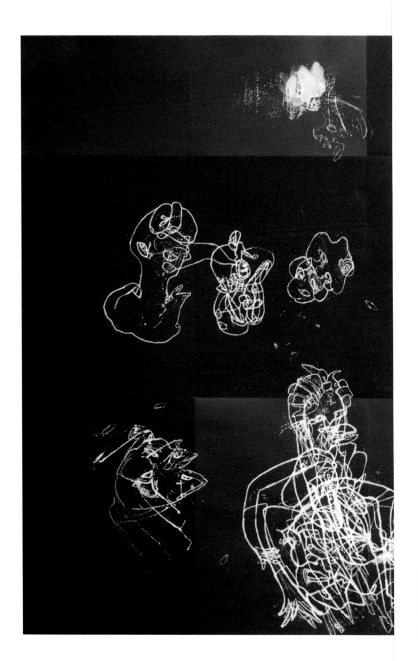

Ed Pien
Professional Mourner, 2011
paper and ink
116.8 x 81 cm
photo courtesy of the artist

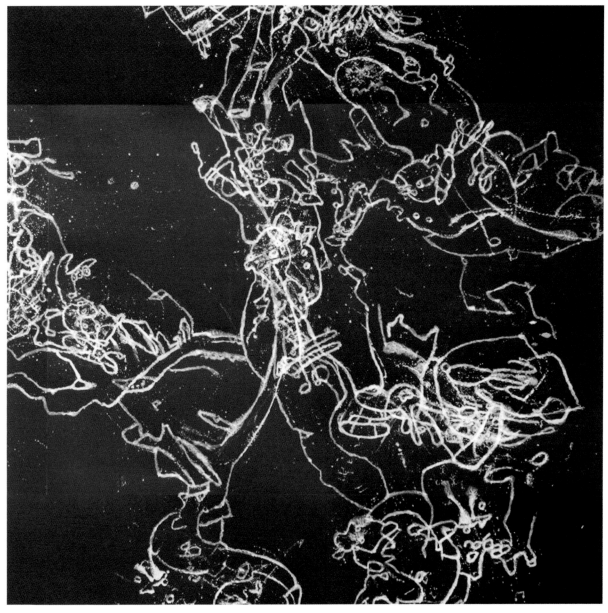

Ed Pien | *Disembodied*, 2012 [detail] | photo courtesy of the artist

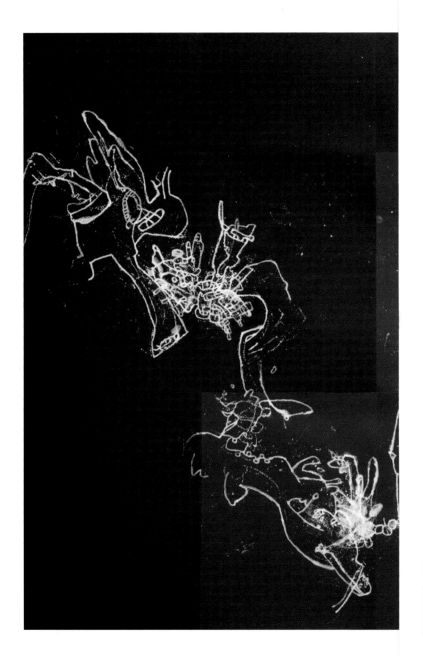

Ed Pien
Disembodied, 2012
paper and ink
116.8 x 81 cm
photo courtesy of the artist

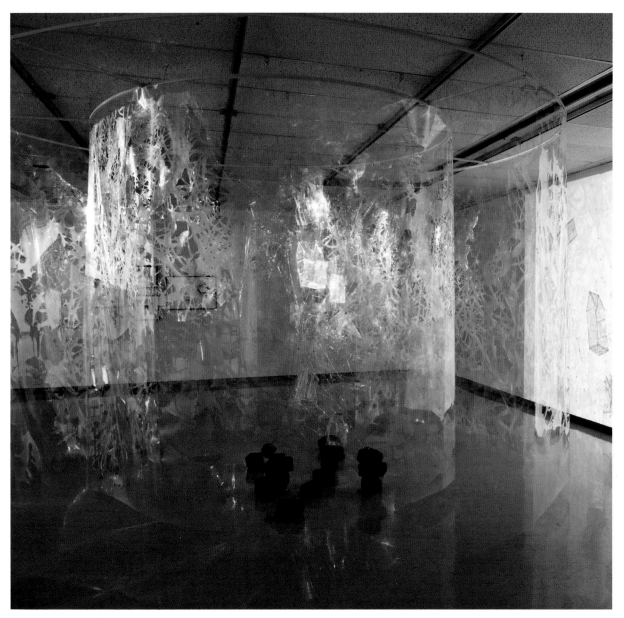

Ed Pien | *Revel*, 2011 | photo courtesy of the artist

Ed Pien
Rope, 2011
ink-jet projection of overlapping
building blocks (or rocks)
2.12 x 4.06 m diameter
sound by Jenny Ham & Phil Beben
mono line loop sound

Ed Pien
Revel, 2011
mylar, projection monofilament,
building blocks (or rocks)
2.7 x 4.26 m diameter
sound by Jenny Pham & Phil Baljeu
photo by Roger Smith

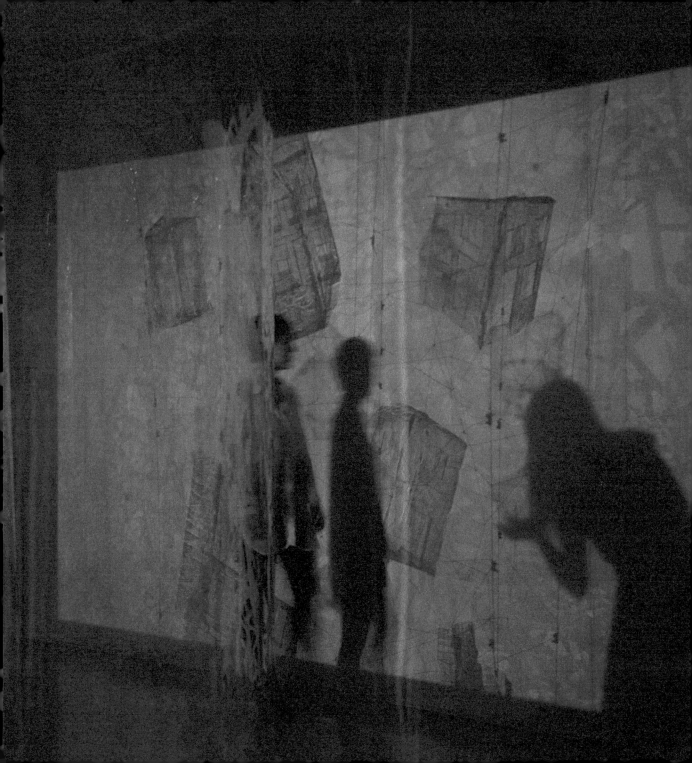

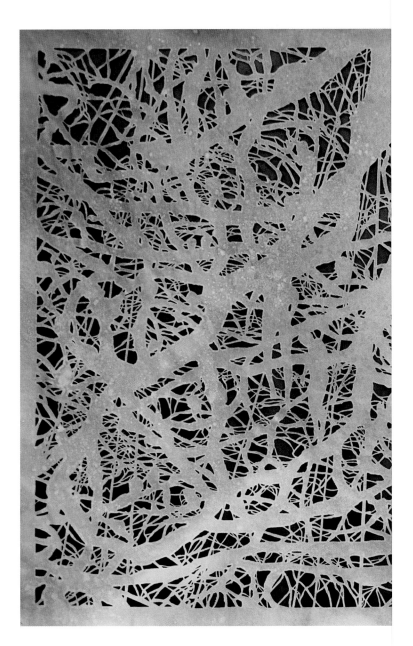

Ed Pien
Twelve, 2012
ink on cut 3M film, laminated
on Kegon paper
2.4 x 3.6 m diameter
photo courtesy of the artist

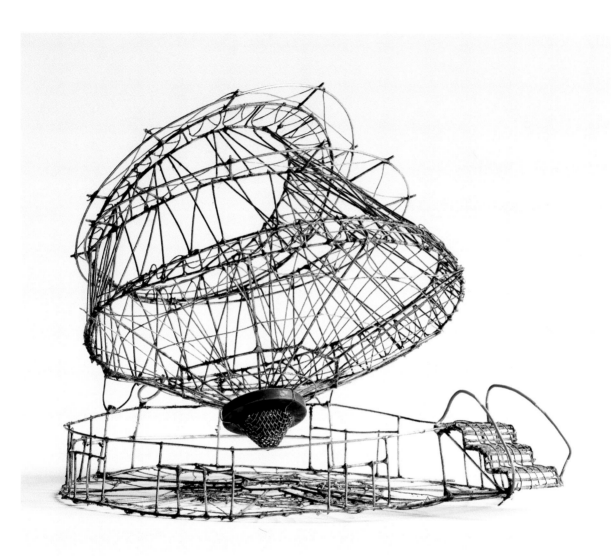

Alison Norlen | *Roundabout*, 2009 | soldered wire | 10 x 12.7 x 12.7 cm | photo by Klaus Rossler

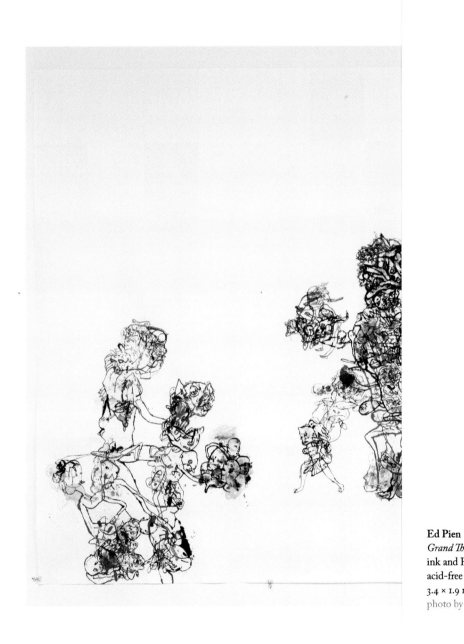

Ed Pien
Grand Thieves, 1999–2010
ink and Flashe on panelled,
acid-free paper
3.4 × 1.9 m
photo by Toni Hafkenscheid

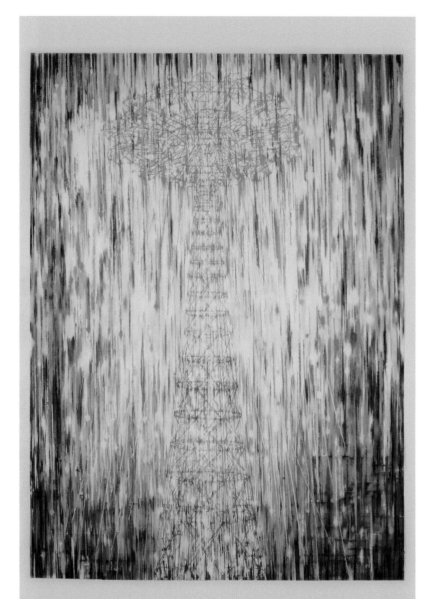

Alison Norlen
Glimmer (*Parachute Drop*), 2009
chalk, charcoal, spray paint
2.9 x 1.8 m
photo by Grant Kernan

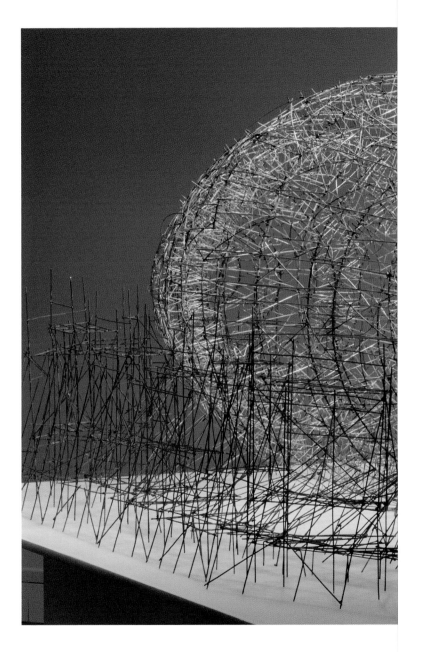

Alison Norlen
Glimmer (*Zeppelin*), 2009
welded/soldered wire
1.06 x 1.2 x 1.5 m
photo by Grant Kernan

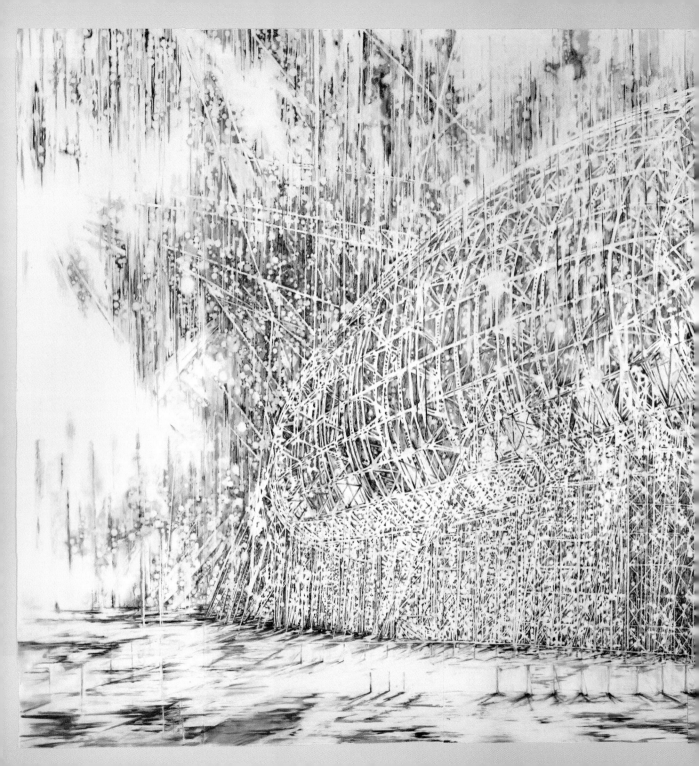

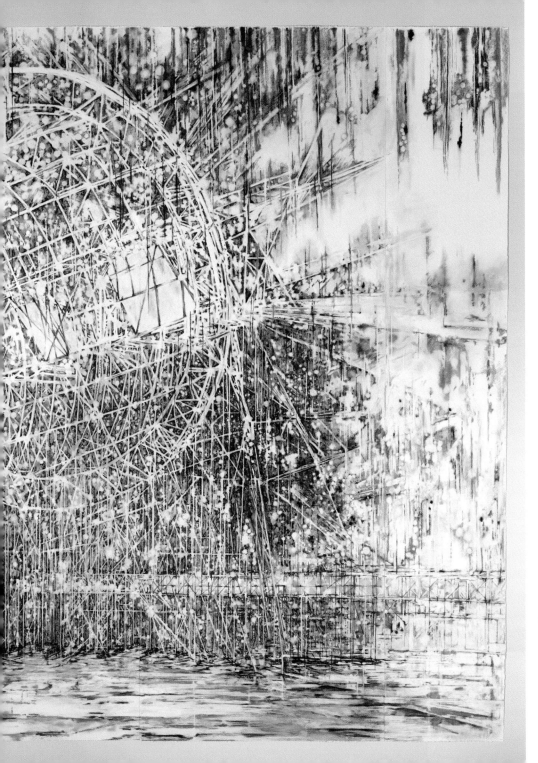

Alison Norlen
Glimmer (*Zeppelin*), 2009
chalk, charcoal
2.9 x 1.8 m
photo by Grant Kernan

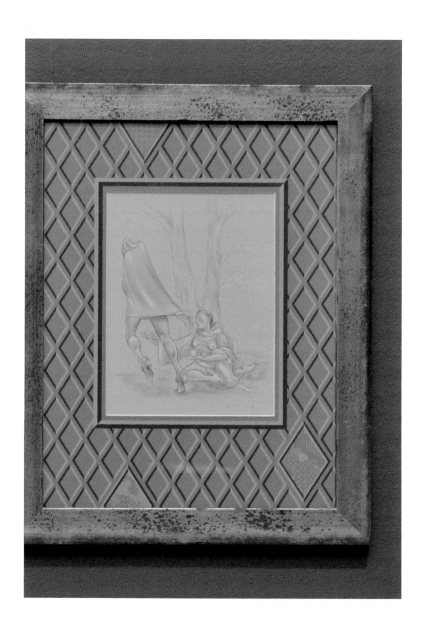

Daniel Barrow | (from left) *Witch* & *Duty*, 2012
photo by Elaine Stocki, WAG

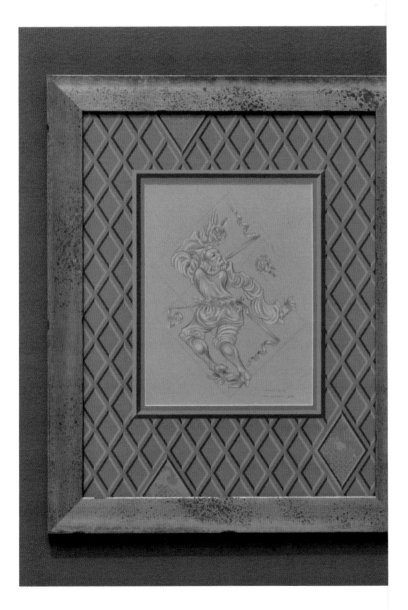

Daniel Barrow | (from left) *Invisible Shrinking Box* & *Vampire*, 2012
photo by Elaine Stocki, WAG

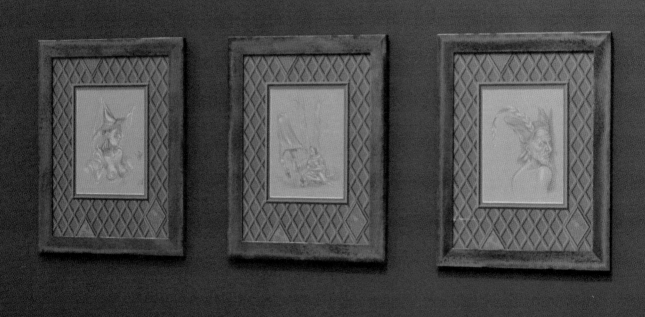

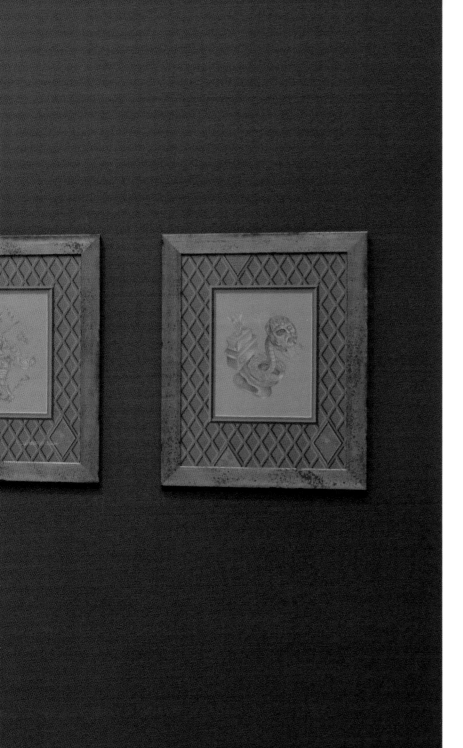

Daniel Barrow
(left to right) *Witch, Duty, Devil, Invisible
Shrinking Box, Vampire*, 2012
chalk pastel, pencil crayon on paper
40.6 x 55.8 cm framed
photo by Elaine Stocki, WAG

LIST

of

WORKS

DANIEL BARROW

The Thief of Mirrors, 2012
mylar, overhead projectors, fans
dimensions variable

Witch, 2012
chalk pastel, pencil crayon on paper
40.6 × 55.8 cm framed

Duty, 2012
chalk pastel, pencil crayon on paper
40.6 × 55.8 cm framed

Devil, 2012
chalk pastel, pencil crayon on paper
40.6 × 55.8 cm framed

Invisible Shrinking Box, 2012
chalk pastel, pencil crayon on paper
40.6 × 55.8 cm framed

Vampire, 2012
chalk pastel, pencil crayon on paper
40.6 × 55.8 cm framed

ALISON NORLEN

Glimmer (*Parachute Drop*), 2009
chalk, charcoal, spray paint
2.9 × 1.8 m

Glimmer (*Zeppelin*), 2009
chalk, charcoal
2.9 × 1.8 m

Glimmer (*Zeppelin*), 2009
welded/soldered wire
1.06 × 1.2 × 1.5 m

Roundabout, 2009
soldered wire
10 × 12.7 × 12.7 cm

ED PIEN

Professional Mourner, 2011
paper and ink
116.8 × 81 cm

Revel, 2011
mylar, projection monofilament, building
blocks (or rocks)
2.7 × 4.26 m diameter
sound by Jenny Pham and Phil Baljeu
videography by Johannes Zits
video editing by Polina Teif
with support from Canada Council for the Arts

Twelve, 2012
3-metre reflector, ink on cut 3M film,
laminated on Kegon paper
2.4 × 3.6 m diameter

Disembodied, 2012
paper and ink
116.8 × 81 cm

Grand Thieves, 1999–2010
ink and Flashe on panelled, acid-free paper
3.4 × 1.9 m

Out-of-Body, 2012
paper and ink
116.8 × 81 cm

Play Rope drawing, 2012
rope
2.7 × 3 m

All works courtesy of the artists

DANIEL BARROW is a Winnipeg-born, Montreal-based artist who uses obsolete technologies to present written, pictorial, and cinematic narratives centring on the practices of drawing and collecting. Since 1993, he has created and adapted comic book narratives for "manual" forms of animation by projecting, layering, and manipulating drawings on overhead projectors.

Barrow has exhibited widely in Canada and abroad. He has performed at the Walker Art Center (Minneapolis, MN), PS1 Contemporary Art Center (New York, NY), the Museum of Contemporary Art (Los Angeles, CA), the International Film Festival Rotterdam, the Portland Institute for Contemporary Art's TBA Festival (Portland, OR), and the British Film Institute (London, UK). Recent exhibitions include Oh Canada! (MASS MoCA, North Adams, MA), and Winnipeg Now (Winnipeg Art Gallery, Winnipeg, MB). Barrow is the winner of the 2010 Sobey Art Award. He is represented by Jessica Bradley Art + Projects (Toronto, ON).

ALISON NORLEN grew up in Kenora, Ontario, and moved to Winnipeg at seventeen to become a barber. While working in a traditional barbershop, she took art classes at the University of Manitoba, eventually obtaining a BFA Honours degree.

She then went on to complete an MFA at Yale University. Norlen returned to Canada and taught at the University of Manitoba for ten years before moving to Saskatoon, where she continues her artistic practice and teaches at the University of Saskatchewan.

Selected solo exhibitions include luna (Mendel Art Gallery, Saskatoon, SK), armature (Arch 2 Gallery, School of Architecture, University of Manitoba, Winnipeg, MB), rollercoaster (Simon Fraser University, Burnaby, BC), edifice (Art Gallery of Kitchener-Waterloo, Kitchener, ON), ala (Oboro, Montreal, QC), float (Mendel Art Gallery, Saskatoon, SK). Selected group exhibitions include Combine (World Loves Saskatchewan) (York Quay Centre, Harbourfront Centre, Toronto, ON), Drawn Positions (National Gallery of Canada, Ottawa, ON), Imagineacity: Architectures for Creativity (Owens Art Gallery, Sackville, NB), Ladder Factories and wheat fields (National Gallery of Canada, Ottawa, ON), Intangible Evidence (The Rooms, St Johns, NL), Just my Imagination (Museum London, London, ON; travelled to Art Gallery of Windsor, Windsor, ON; MOCCA, Toronto, ON; Mendel Art Gallery, Saskatoon, SK; and Art Gallery of Algoma, Sault Ste Marie, ON), and Wonderland (Museum London, London, ON). International exhibitions include Faux Real (Blank Project, Ann Arbor, MI),

ARTIST
BIOGRAPHIES

ARTIST
BIOGRAPHIES

MosaiCanada; Sign& Sound (Seoul, Korea), Tekeningen III (Quartair Art Contemporary Art Initiatives Dutch/Canada, The Hague, Neth.), and the LA International Biennial Invitational, and Exhibition of America, 10th Annual Biennial in Printmaking (X Mostra Da Gravura, Curitiba, Brazil).

Norlen's work has been shown in provincial, national, and international exhibitions. Her work is in private collections in the United States and Canada, and is included in public collections such as the Manitoba Arts Council, the Canada Council Art Bank, the Saskatchewan Arts Board, Winnipeg Art Gallery, the Mendel Art Gallery, the Mackenzie Art Gallery, Confederation Centre for the Arts, and the National Gallery. Norlen has received grants from the Canada Council for the Arts, the Manitoba Arts Council, and the Saskatchewan Arts Board; has been the recipient of an International Artist Residency in Trinidad from the Canada Council for the Arts; and recently received the International Artist Residency for Paris.

ED PIEN is a Canadian artist based in Toronto. He has been drawing for nearly thirty years. Born in Taipei, Taiwan, he immigrated to Canada with his family at the age of eleven. He holds a BFA from the University of Western Ontario in London, ON, and an MFA from York University in Toronto.

Ed Pien has exhibited nationally and internationally, including at the Drawing Centre (New York, NY), La Biennale de Montreal 2000 and 2002 (Montreal, QC), W139 (Amsterdam, Neth.), Contemporary Art Gallery (Vancouver, BC), Middlesbrough Art Gallery (Middlesbrough, UK), Centro Nacional de las Artes (Mexico City, MX), the Contemporary Art Museum in Monterrey (Monterrey, MX), the Goethe Institute (Berlin, DE), Bluecoat (Liverpool, UK), Art Gallery of Ontario (Toronto, ON), and the National Gallery of Canada (Ottawa, ON). Recent exhibitions include all our relations (18th Sydney Biennale, Sydney, Australia) and Oh Canada! (MASS MoCA, North Adams, MA). As an art instructor, Ed Pien has taught at the Emily Carr Institute of Art and Design, Nova Scotia College of Art and Design, and the Ontario College of Art and Design.

Pien currently teaches part-time at the University of Toronto. He is represented by Birch Libralato (Toronto, ON), Pierre-François Ouellette Art Contemporain (Montreal, QC), and Galerie Maurits van de Laar (The Hague, Neth.).

Curator | **Nicole Stanbridge**
Contributor | **Sally Frater**
Publication Project Manager | **Nicole Stanbridge**
Editor | **Audrey McClellan**
Publication Design | **Michael Erdmann**
Printed in Canada by **Hemlock Printers Ltd.**

Thank you to the artists, Daniel Barrow, Alison Norlen, Ed Pien, and to AGGV staff for their contributions to the success of this exhibition. Thank you Sally Frater, Michael Erdmann, and Audrey McClellan for their creativity and contributions to this publication.

Art Gallery of Greater Victoria
1040 Moss Street
Victoria, British Columbia
Canada V8V 4P1
1.250.384.4171 | aggv.ca

 Canada Council Conseil des Arts
for the Arts du Canada

Library and Archives Canada Cataloguing in Publication
Stanbridge, Nicole, 1976-
 Traces : fantasy worlds and tales of truth / Nicole Stanbridge, Sally Frater.
Catalogue of an exhibition held at the Art Gallery of Greater Victoria
 from Jan. 18 - April 21, 2013.
ISBN 978-0-88885-372-1

 1. Barrow, Daniel--Exhibitions. 2. Norlen, Alison--Exhibitions.
3. Pien, Ed--Exhibitions. I. Barrow, Daniel II. Norlen, Alison
III. Pien, Ed IV. Frater, Sally, 1974- V. Art Gallery of Greater
Victoria VI. Title.
NC141.S73 2013 741.971074'71128 C2012-907612-0

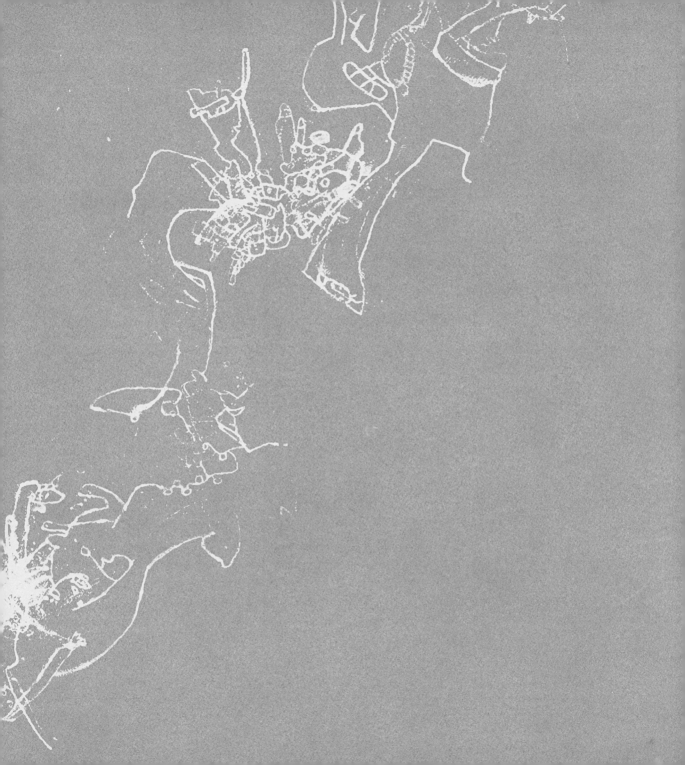

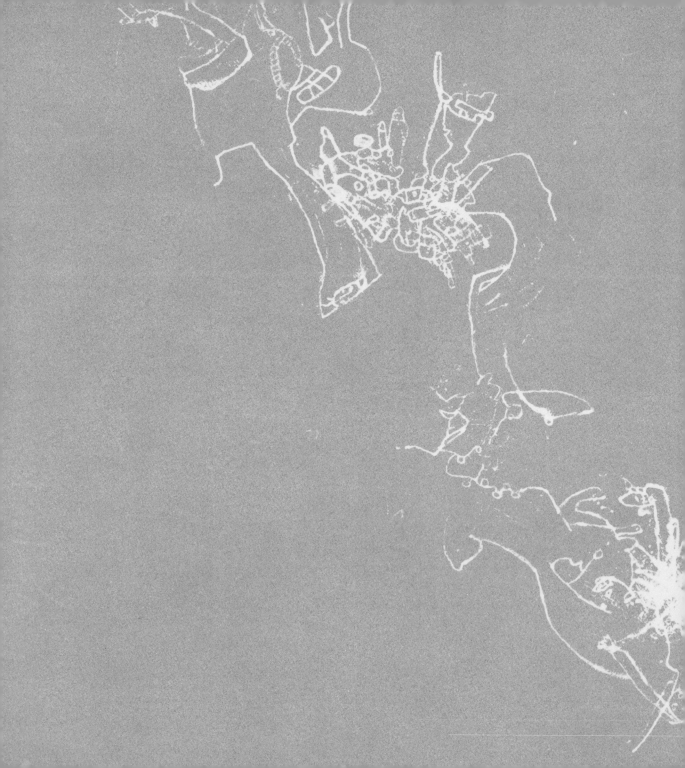